Venice in November

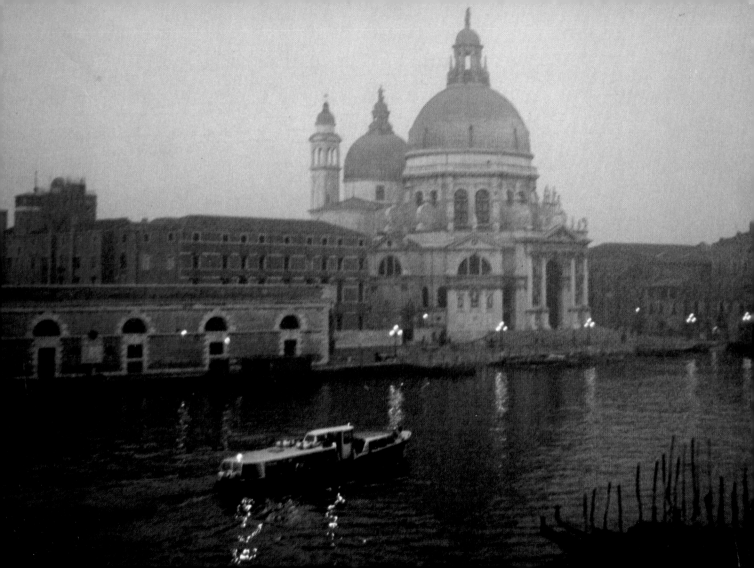

Ted Scapa
Venice in November

Barron's

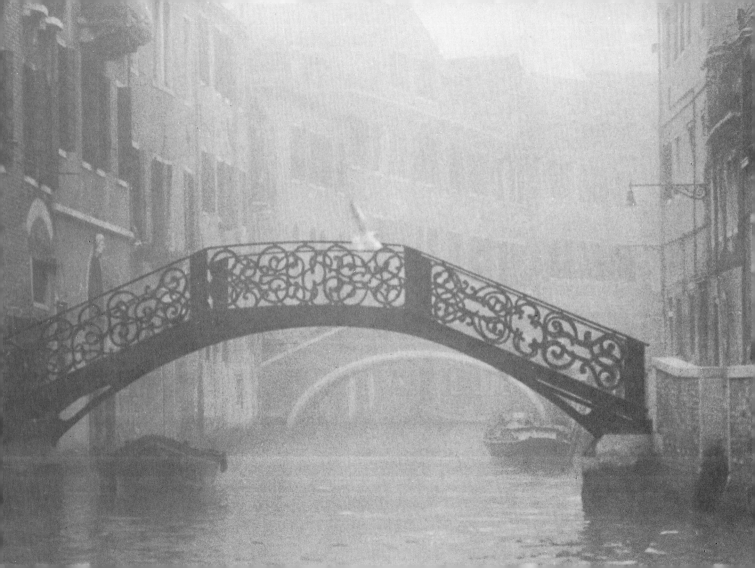

Venice,

when you embrace me in your November mist,

I drift into a deep reverie.

I never feel more in love and happier,

than when I awaken in you and feel

that we have not become older, but eternal.

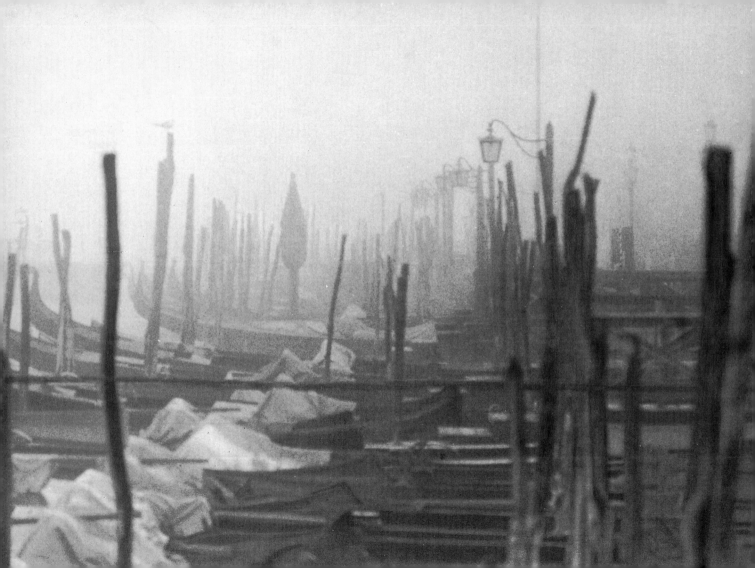

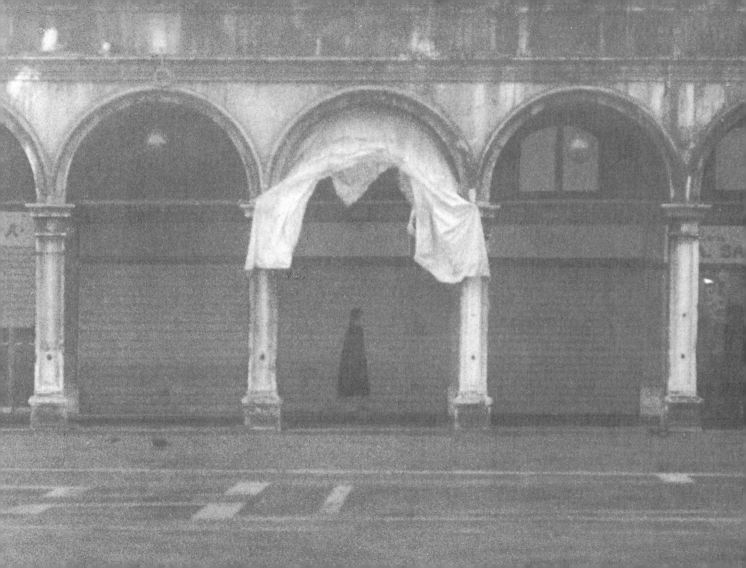

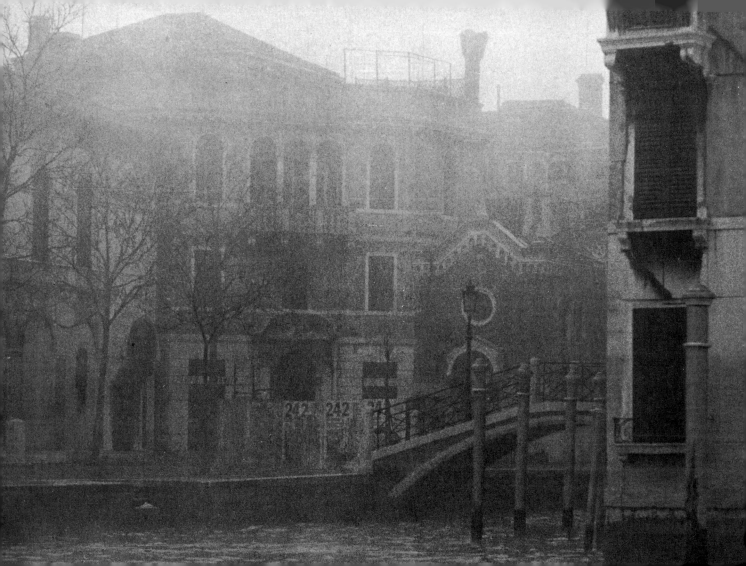

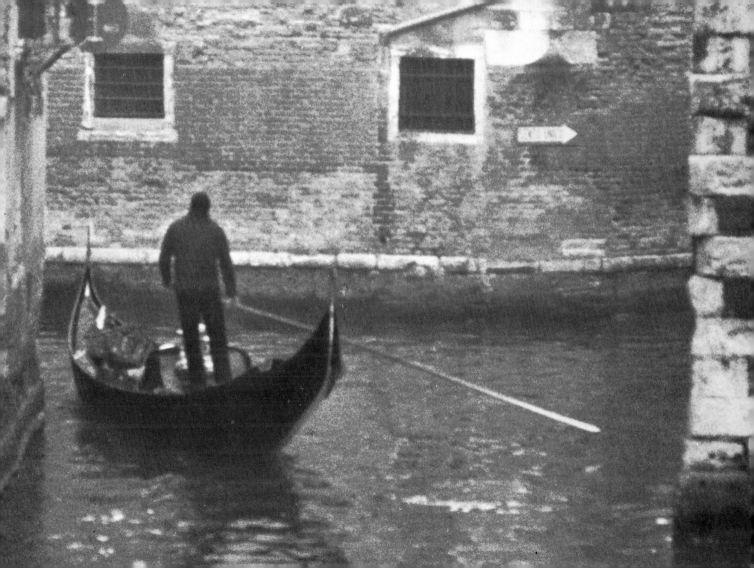

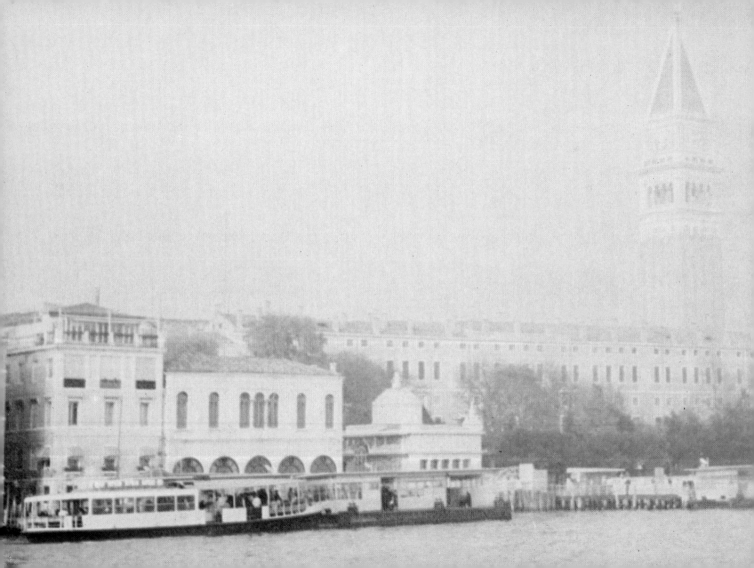

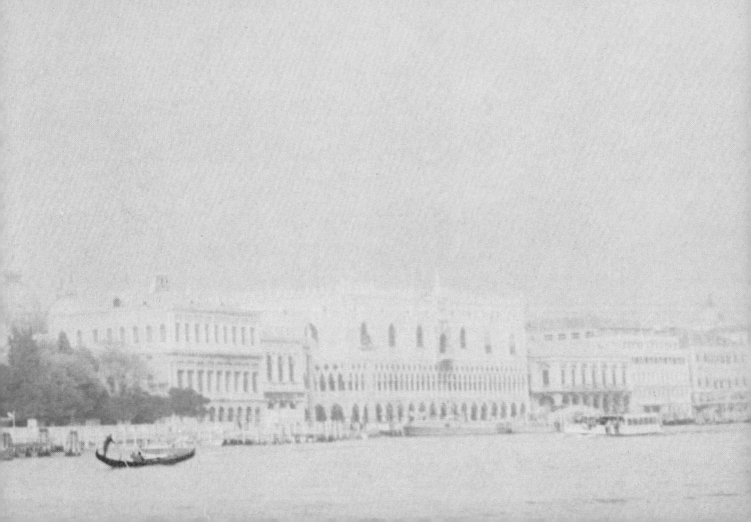

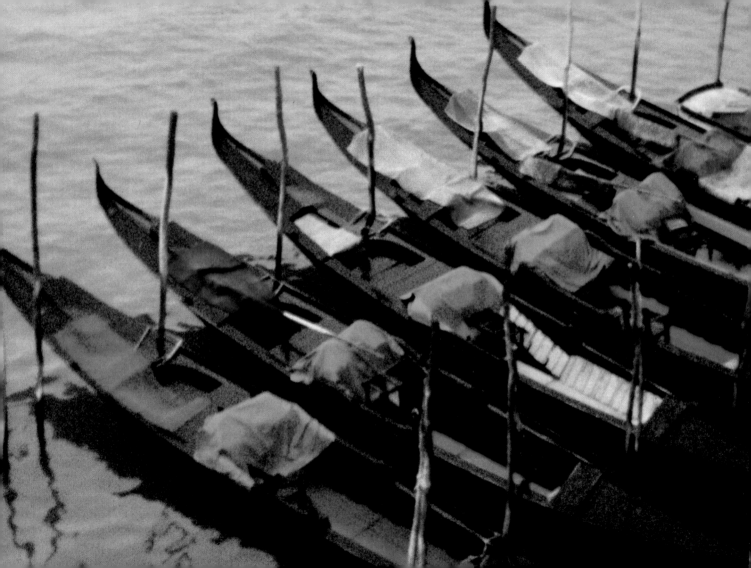

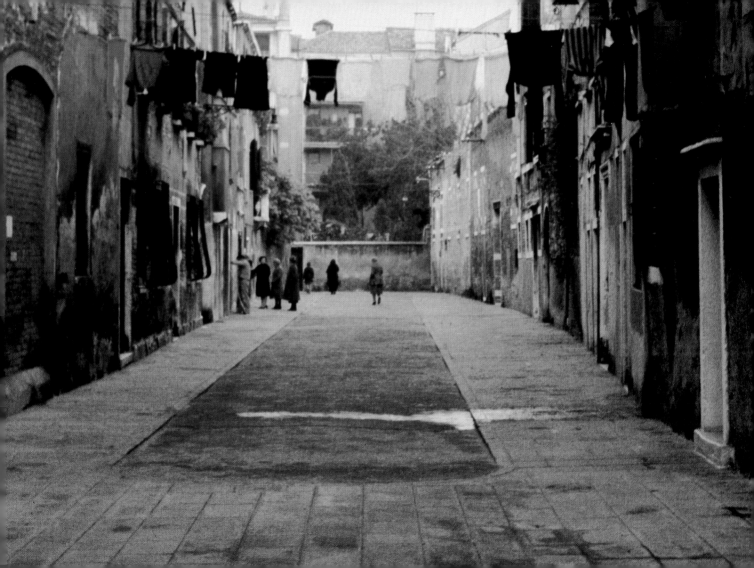

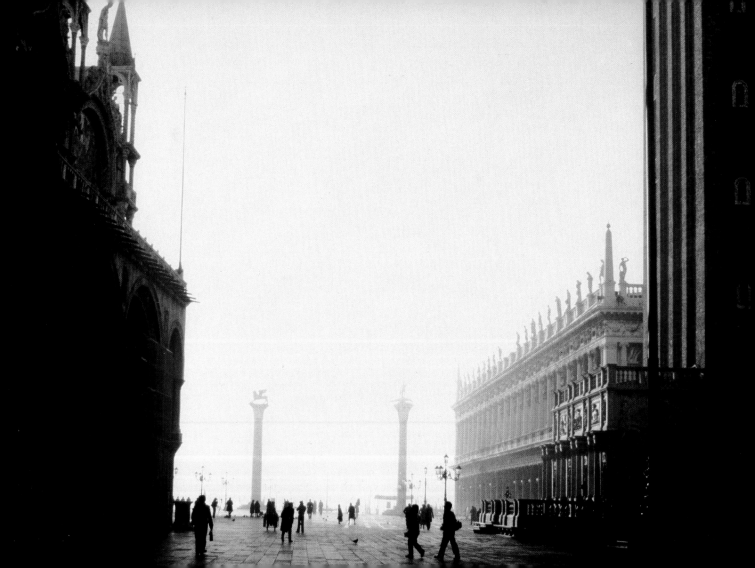

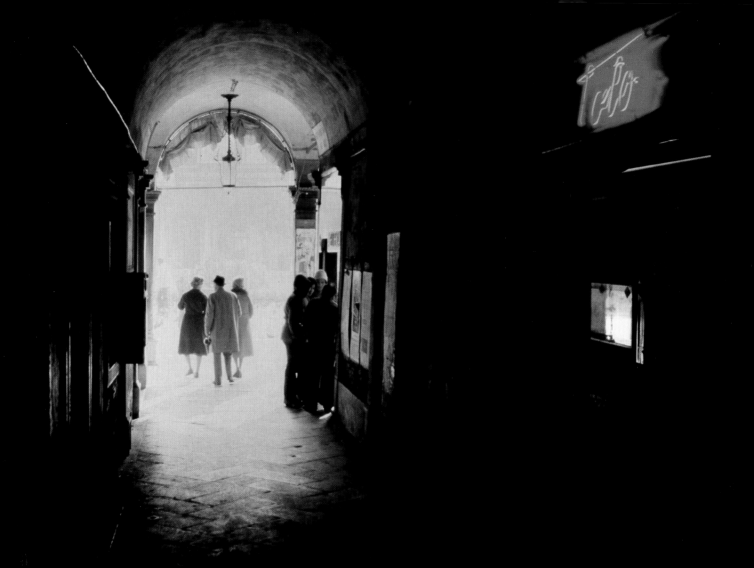

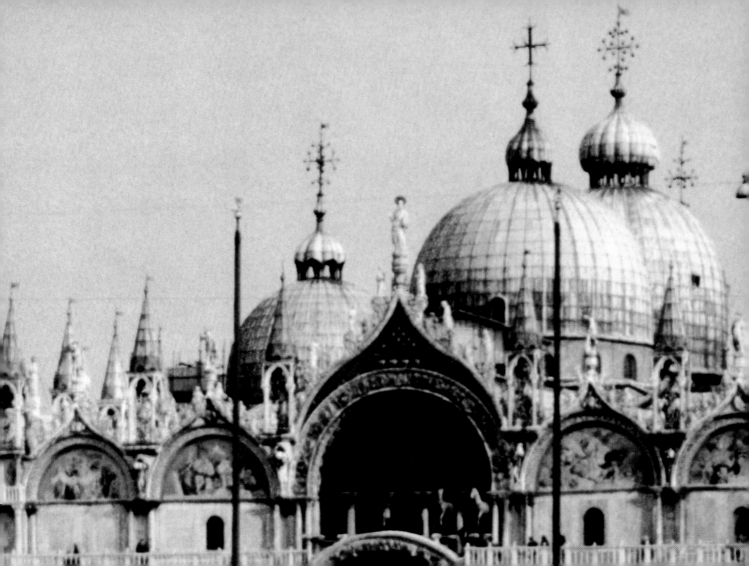

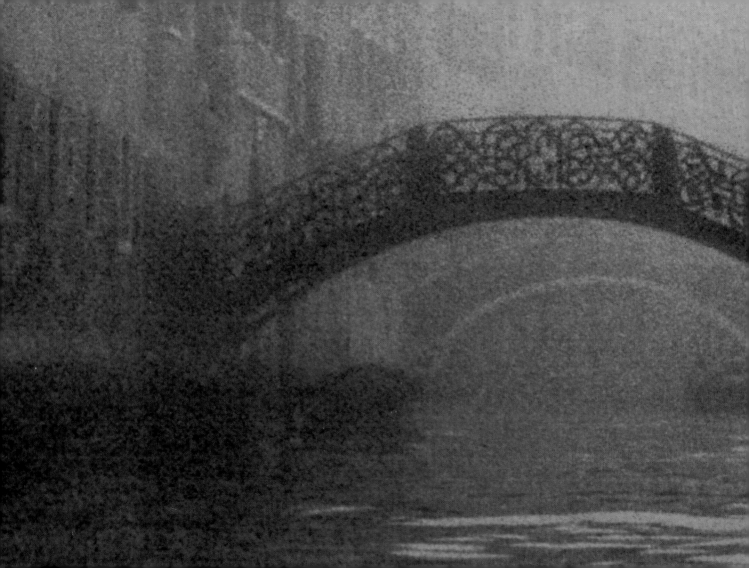

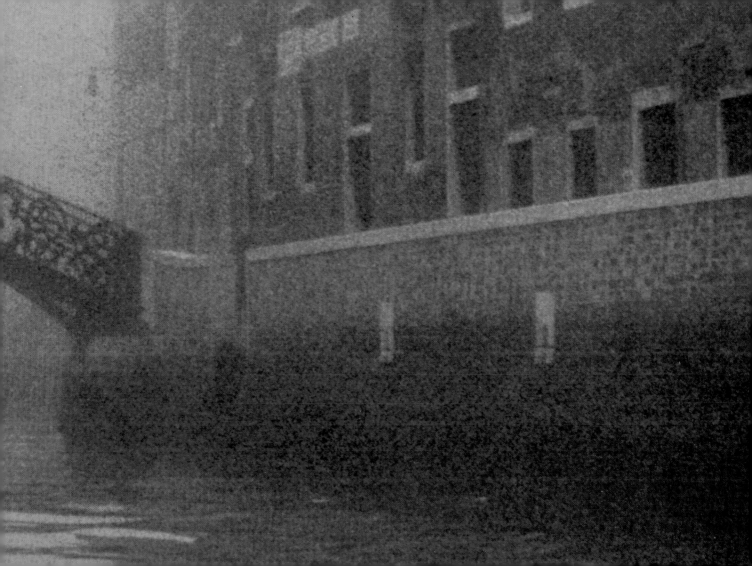

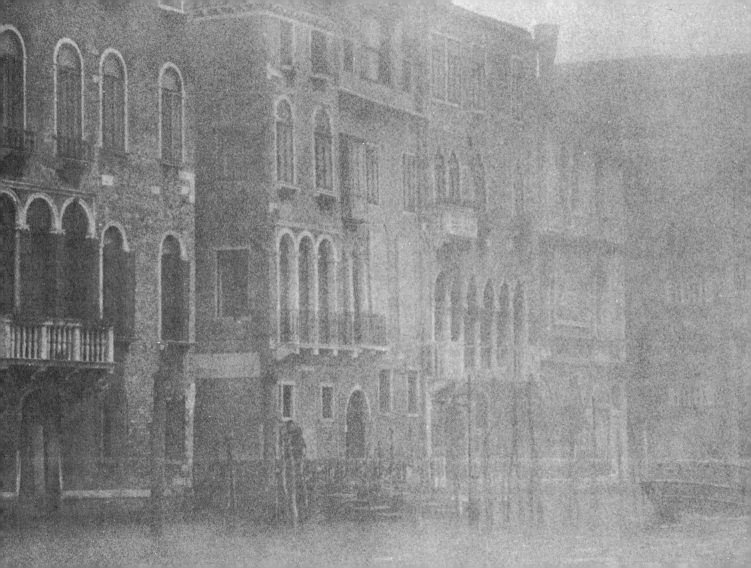

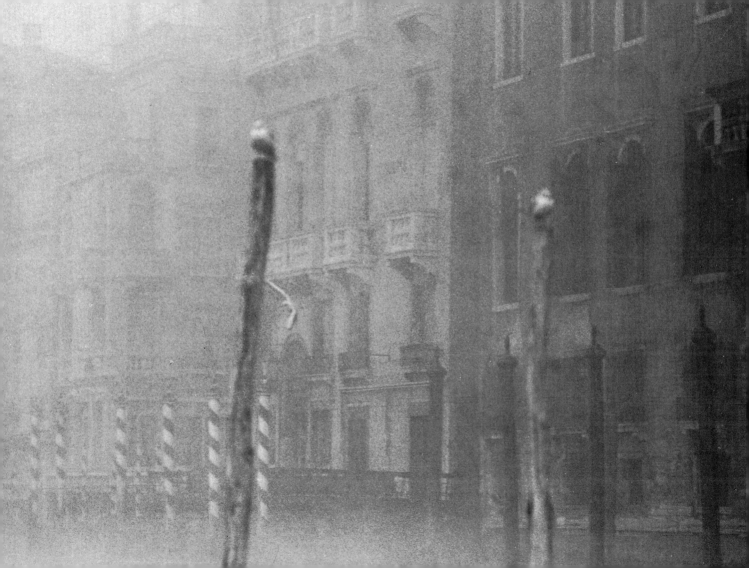

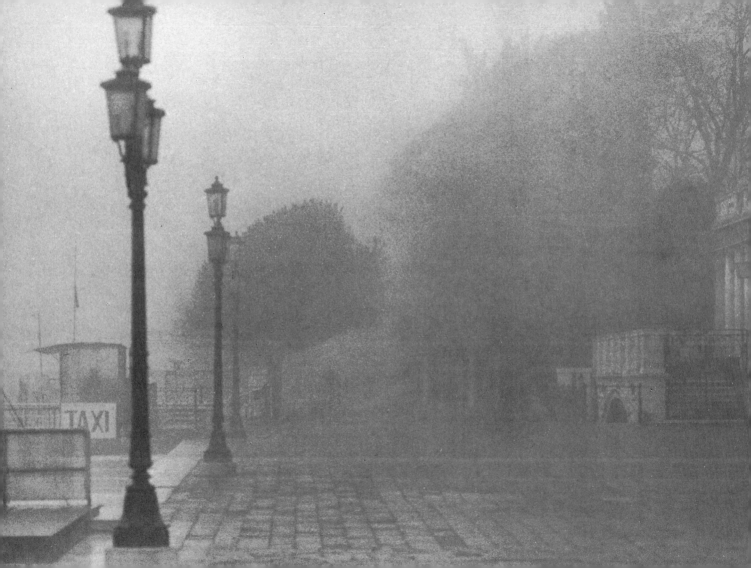

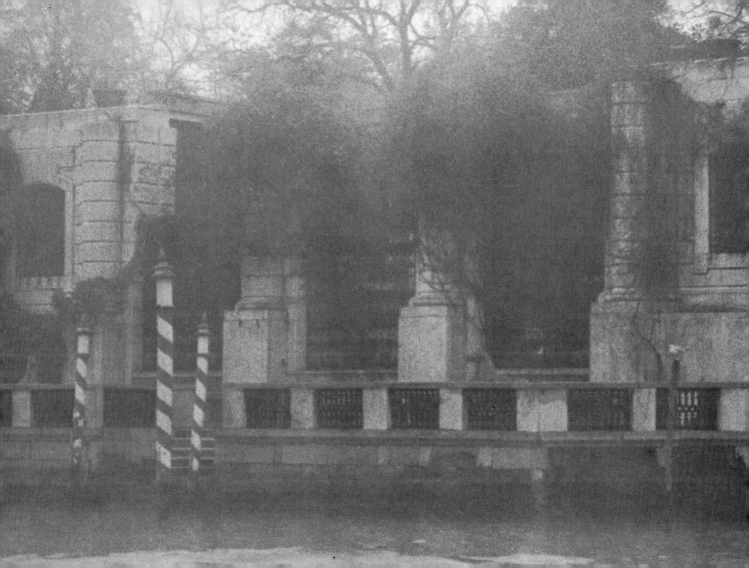

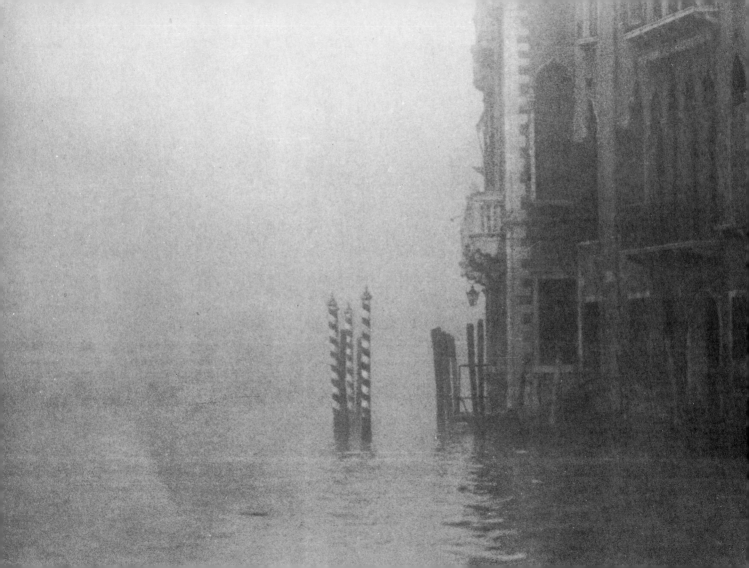

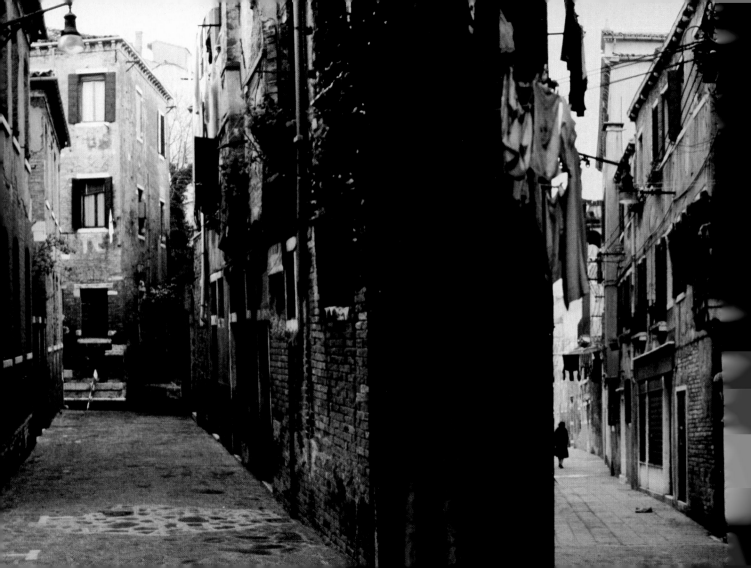

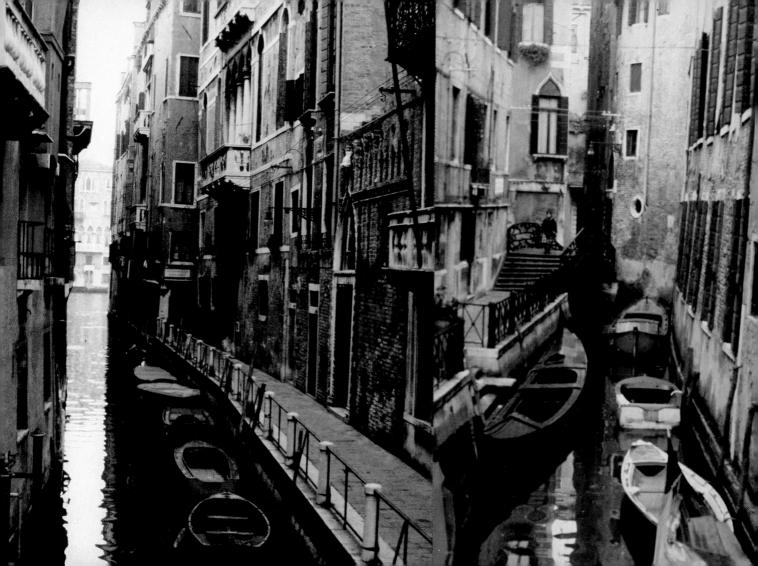

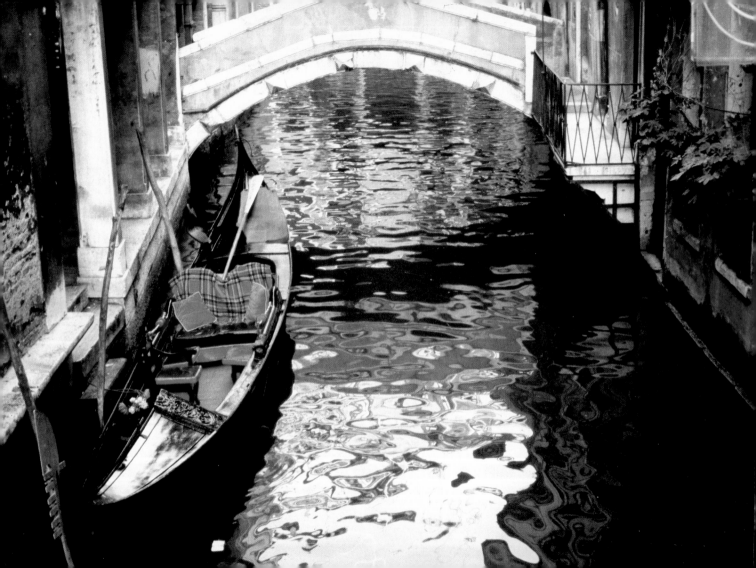

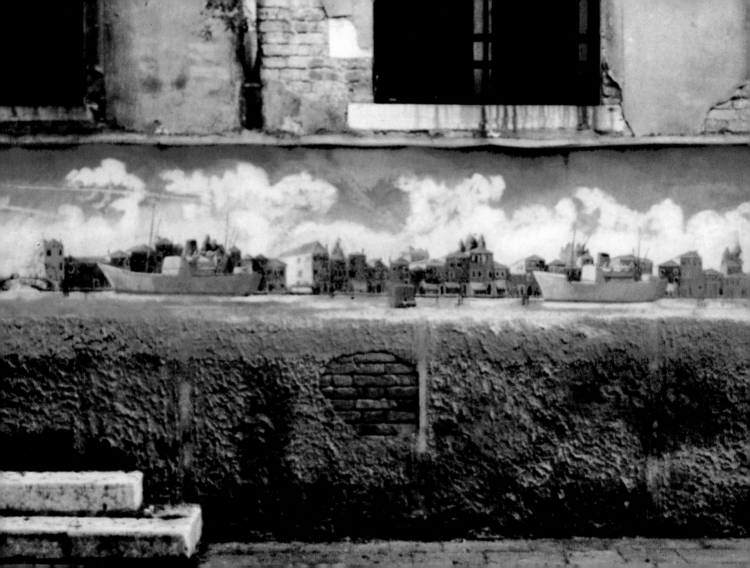

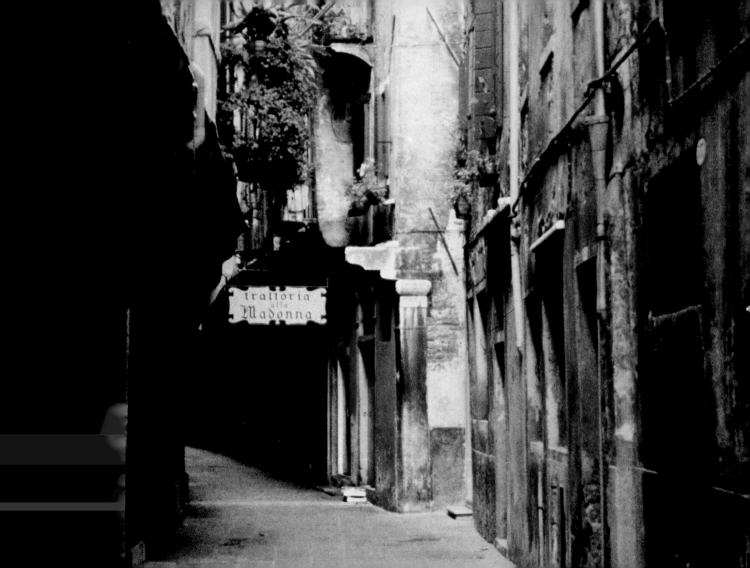

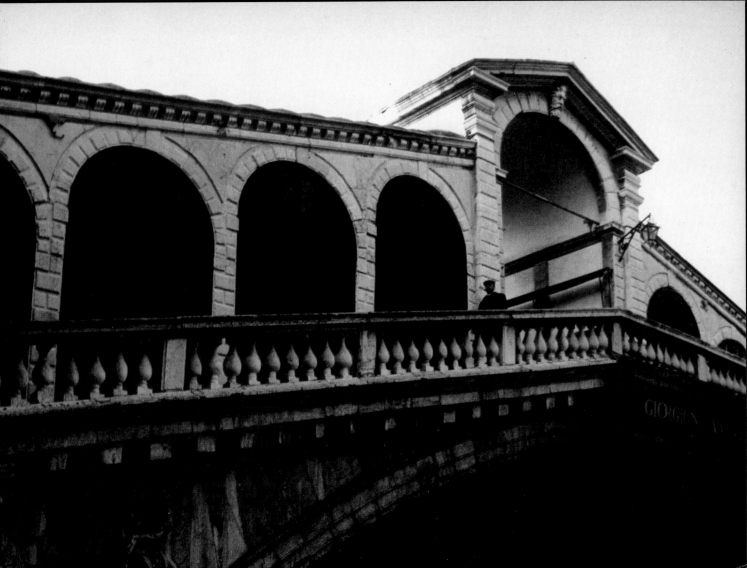

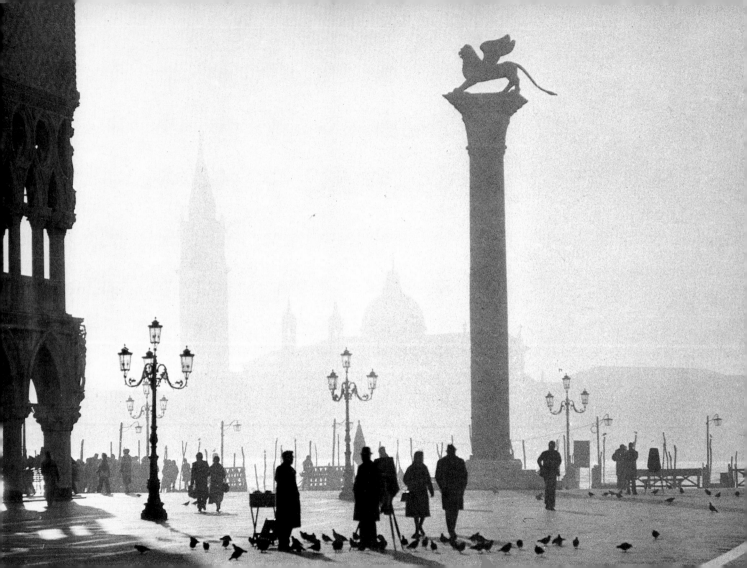

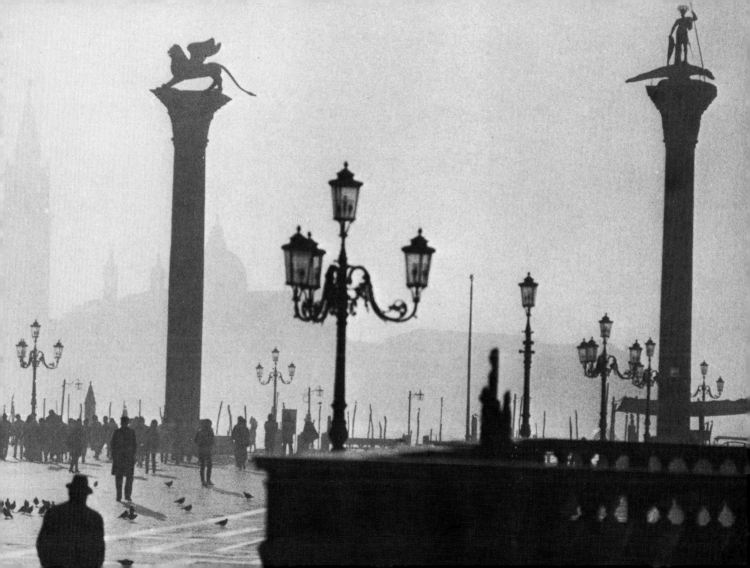

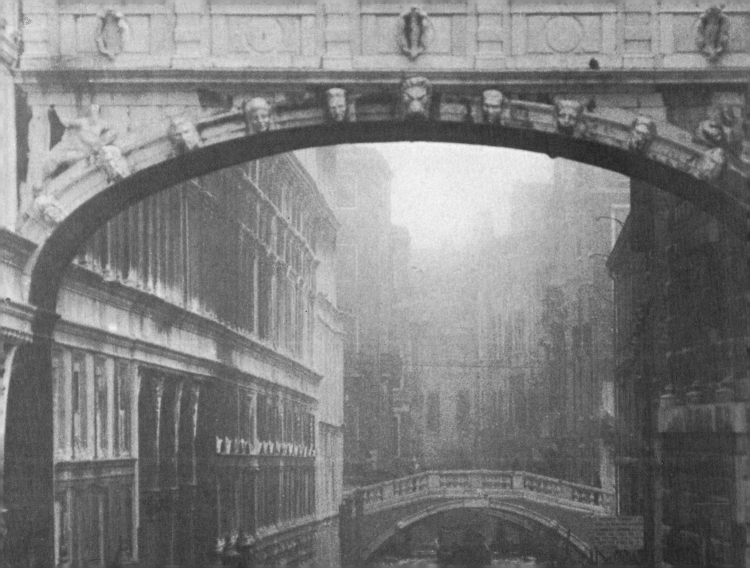

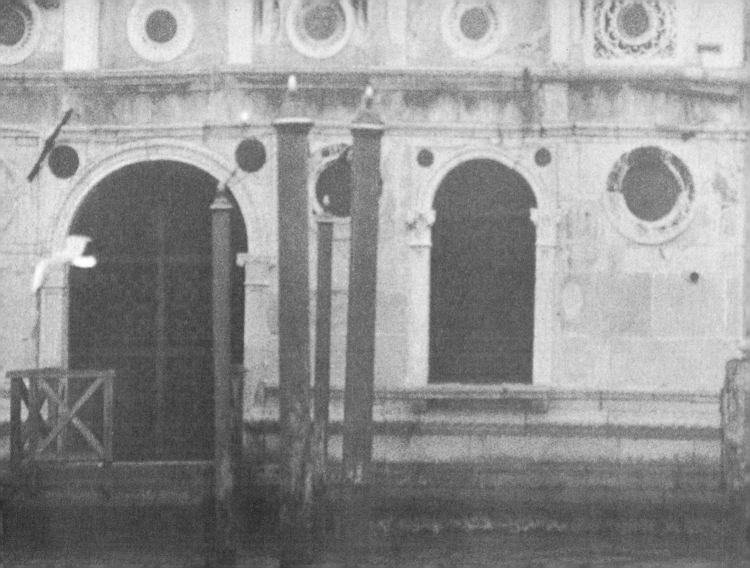

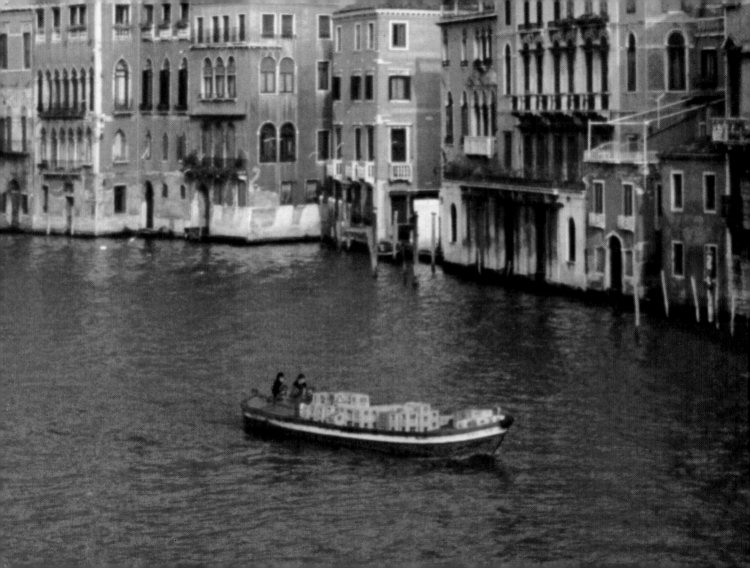

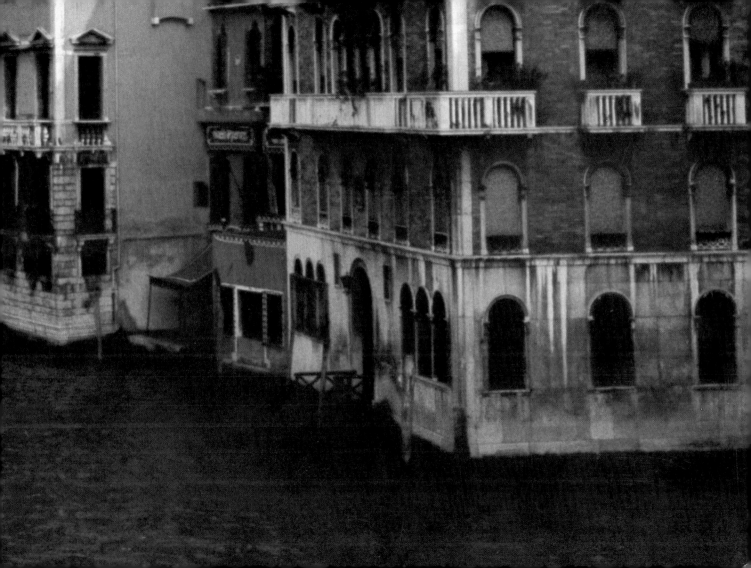

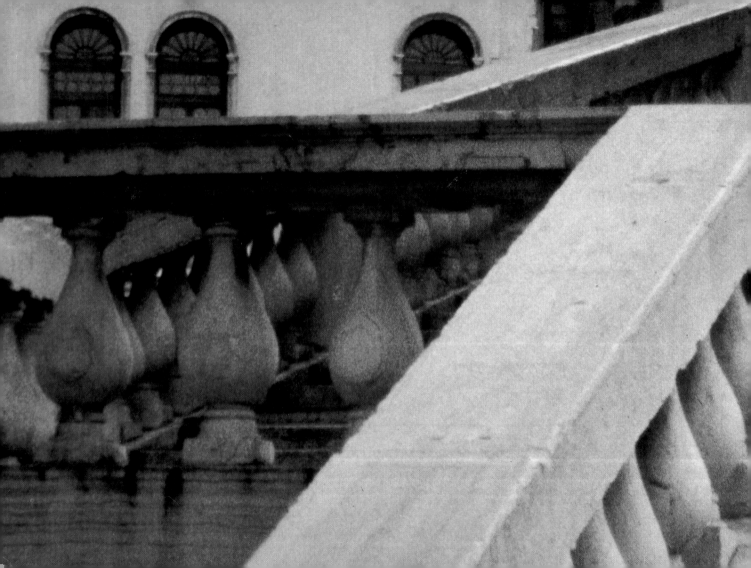

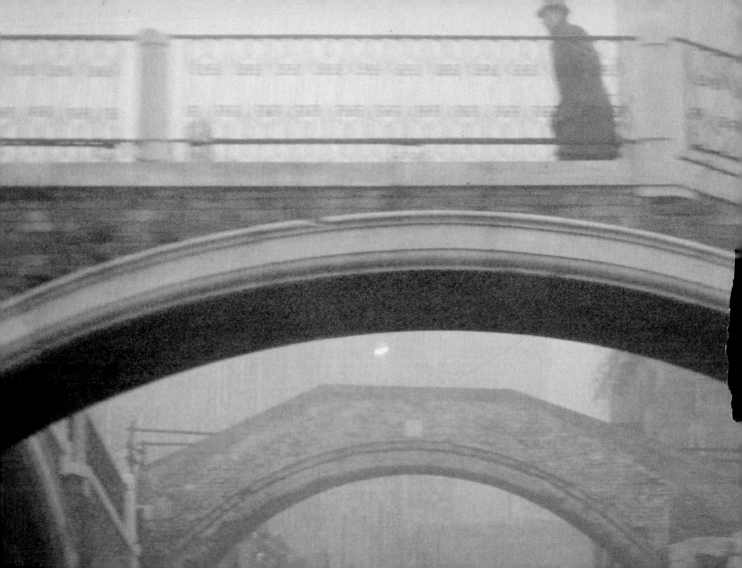

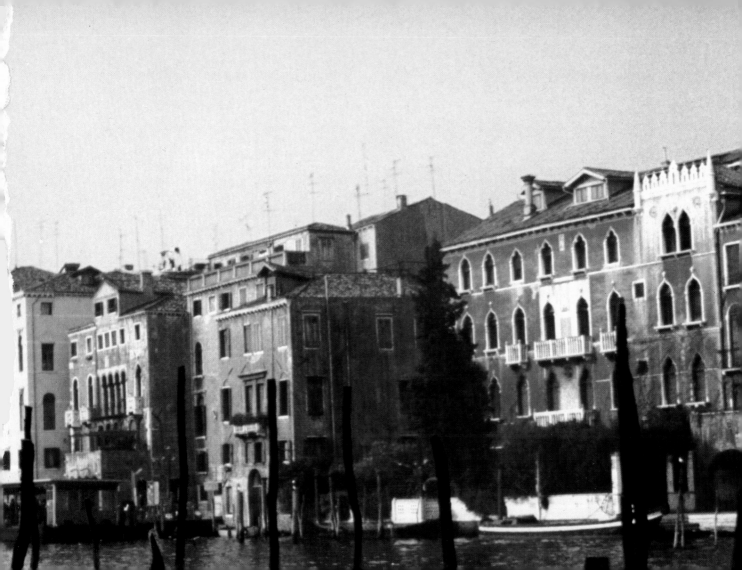

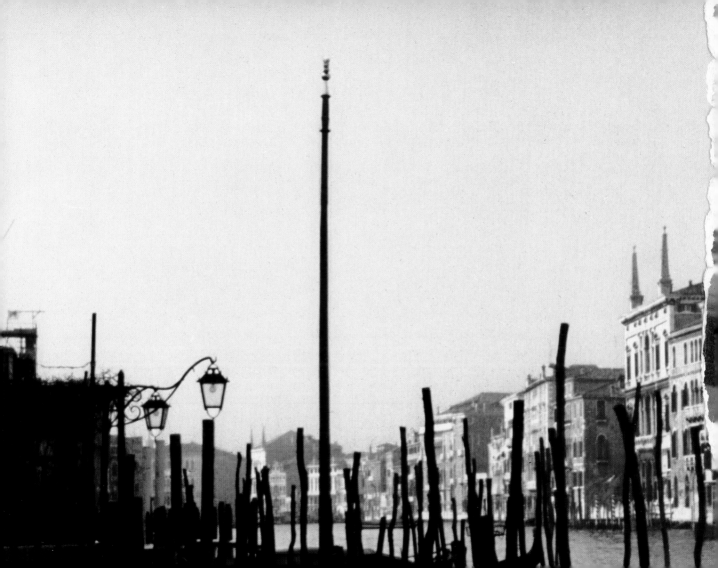

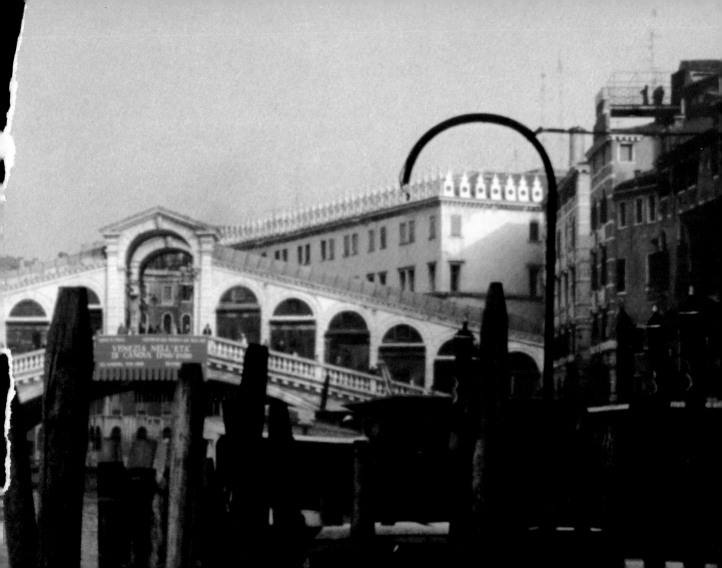

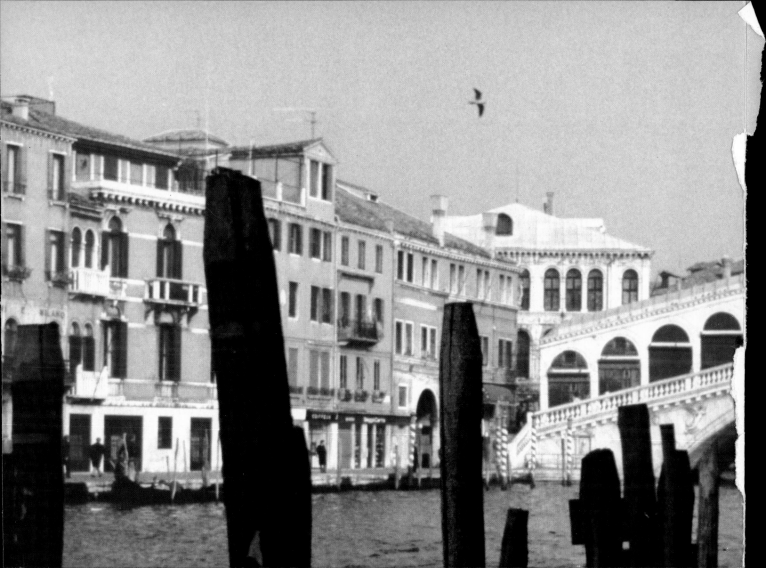

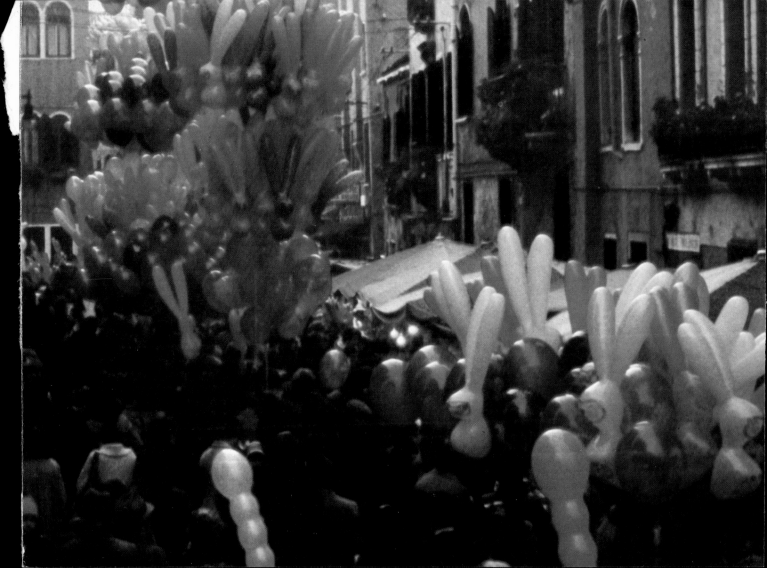

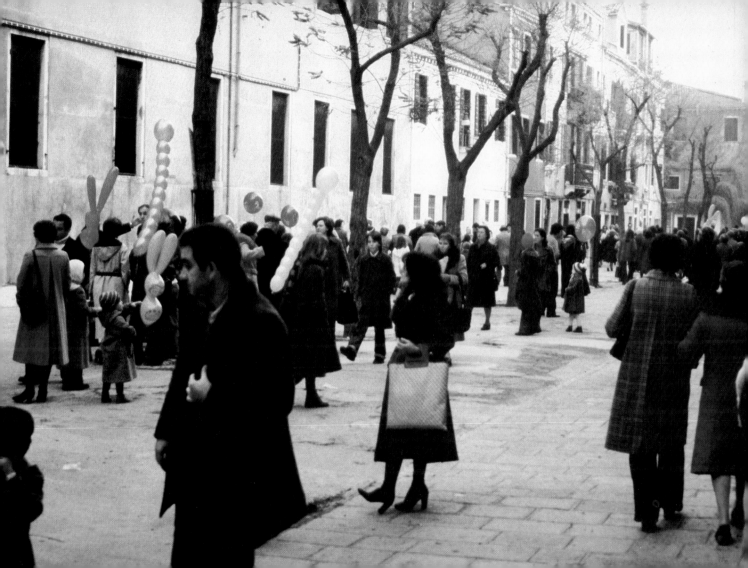

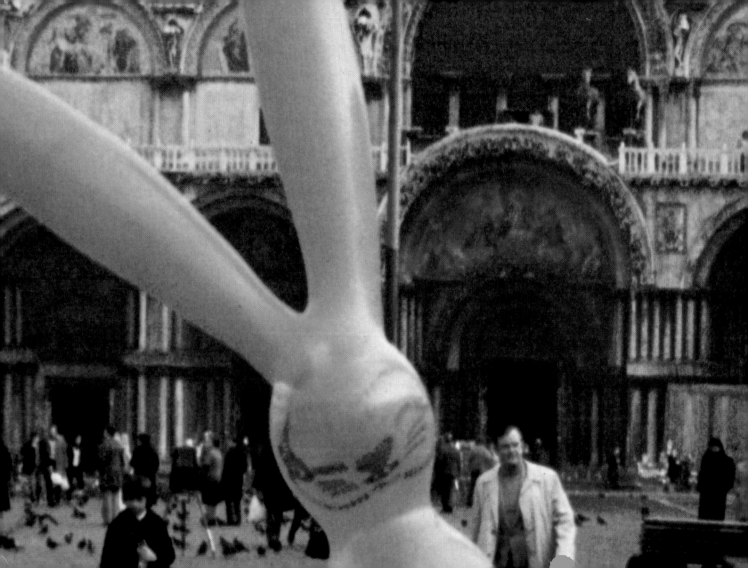

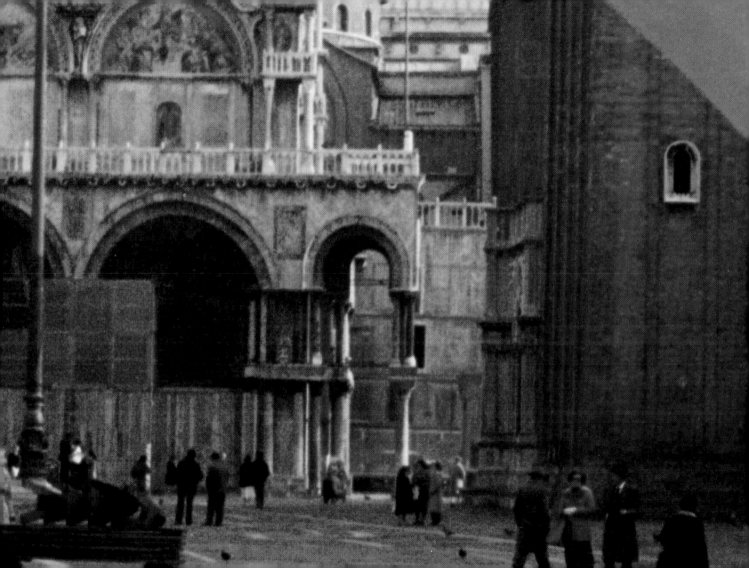

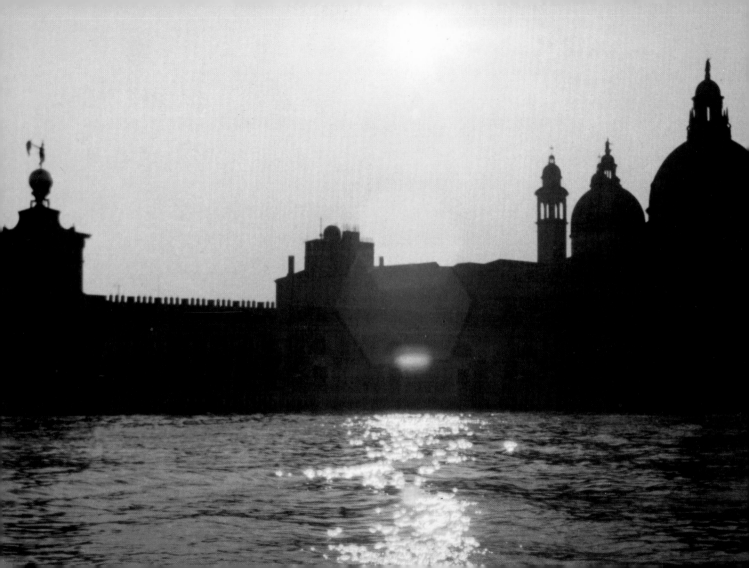

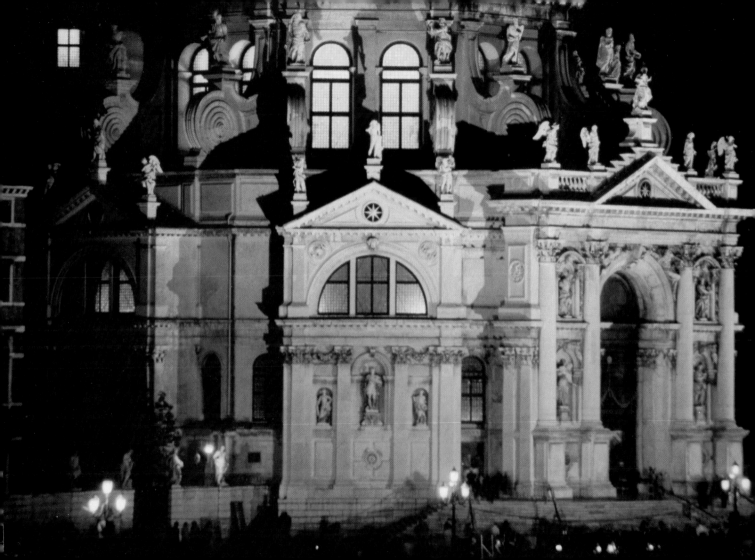

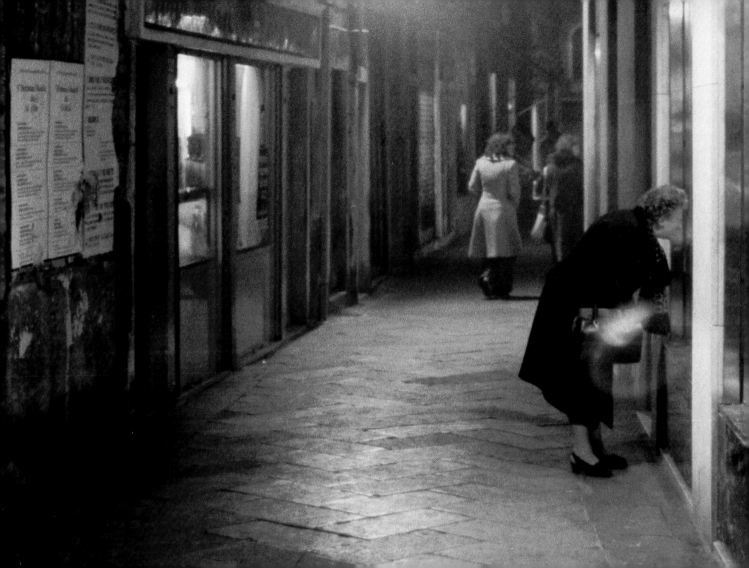

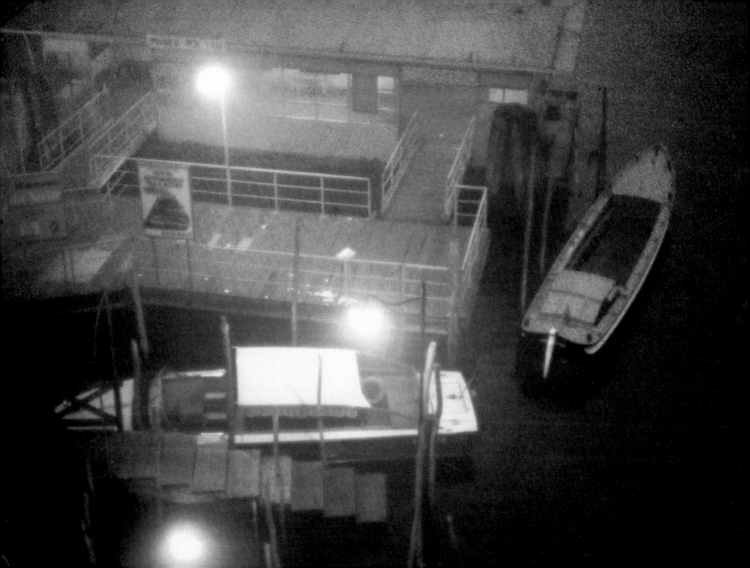

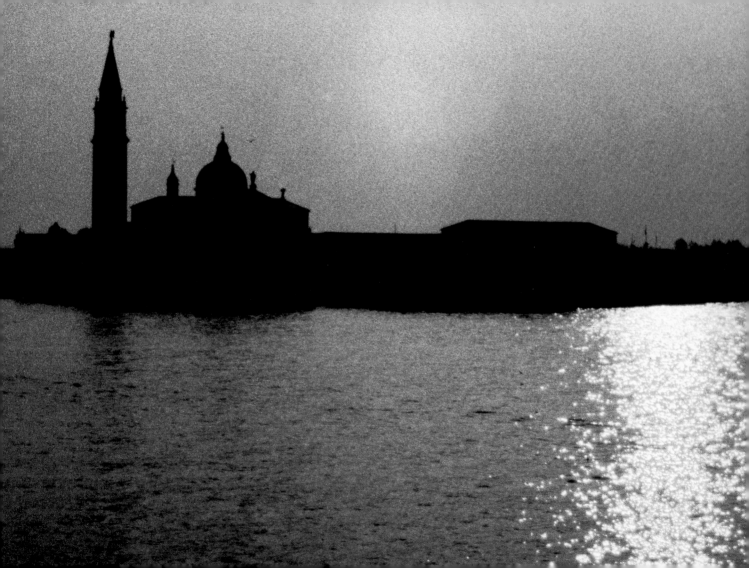

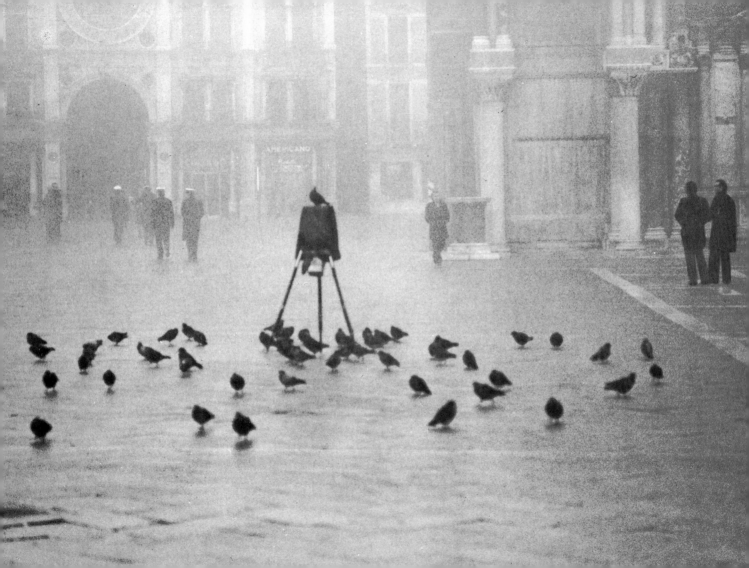

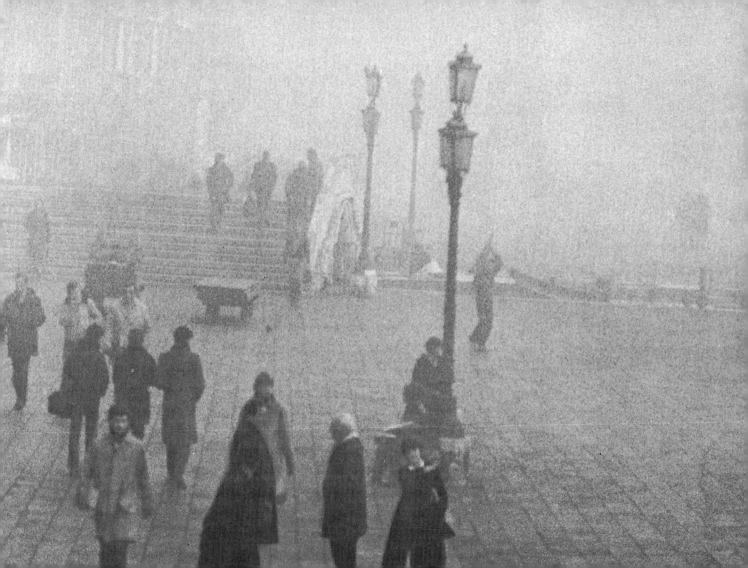

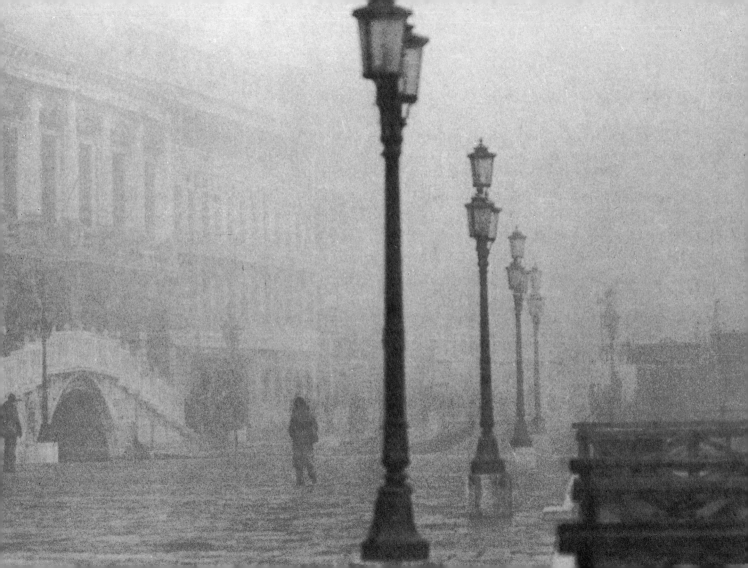

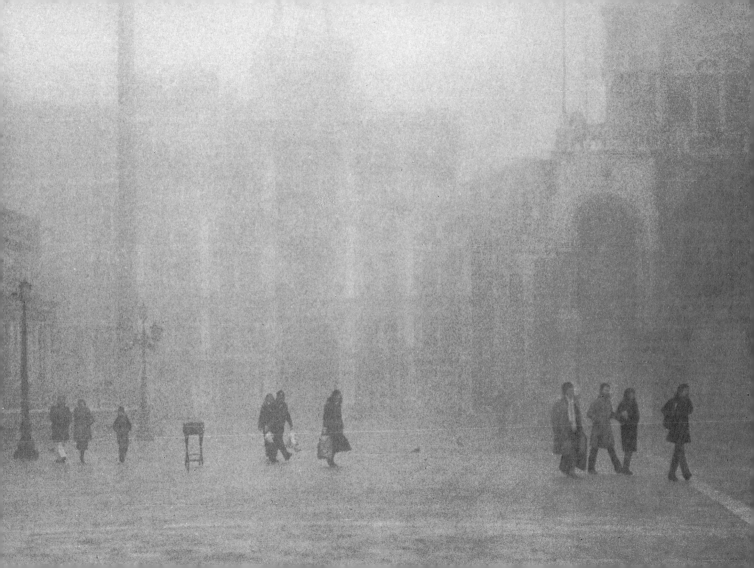

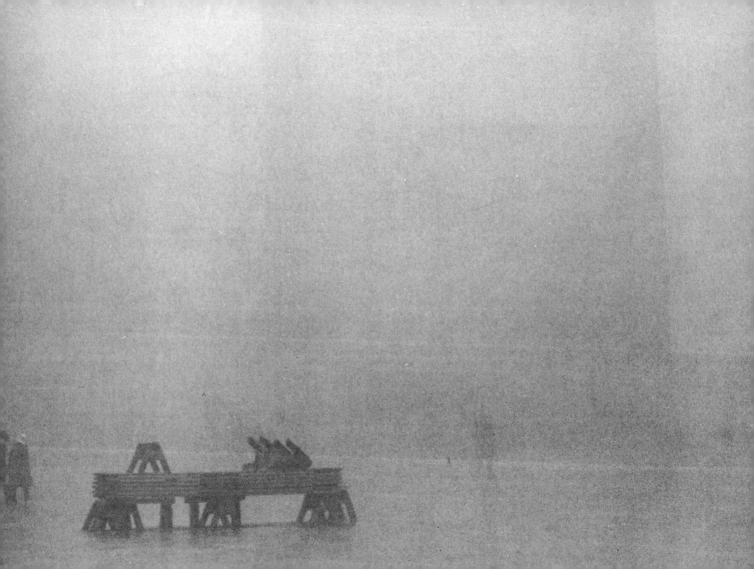

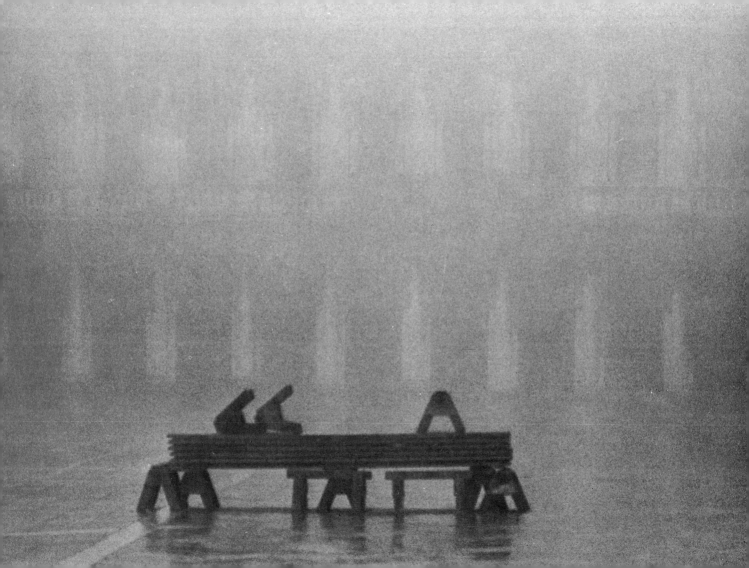

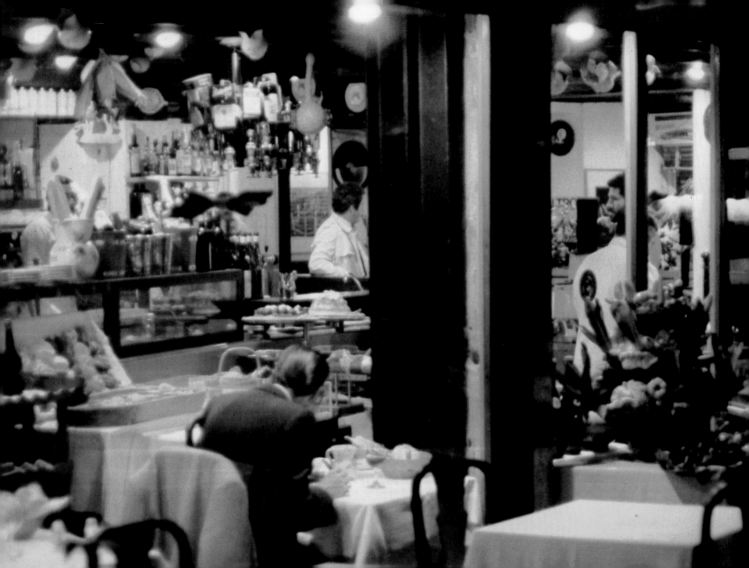

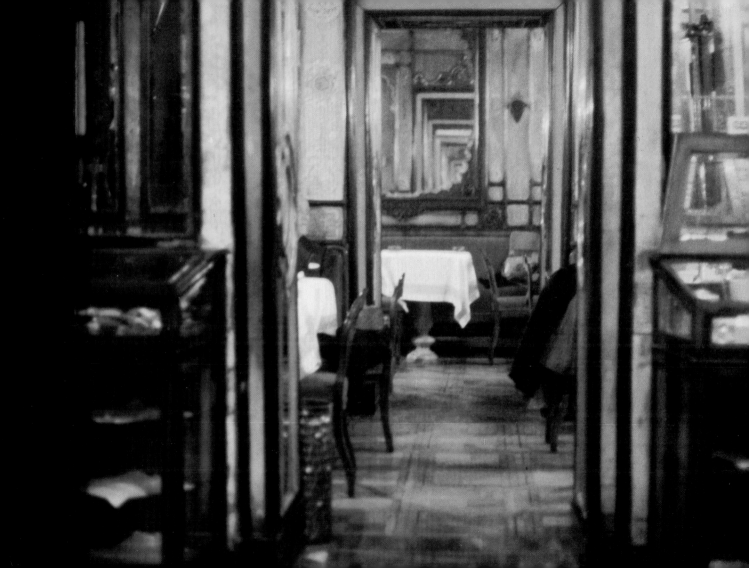

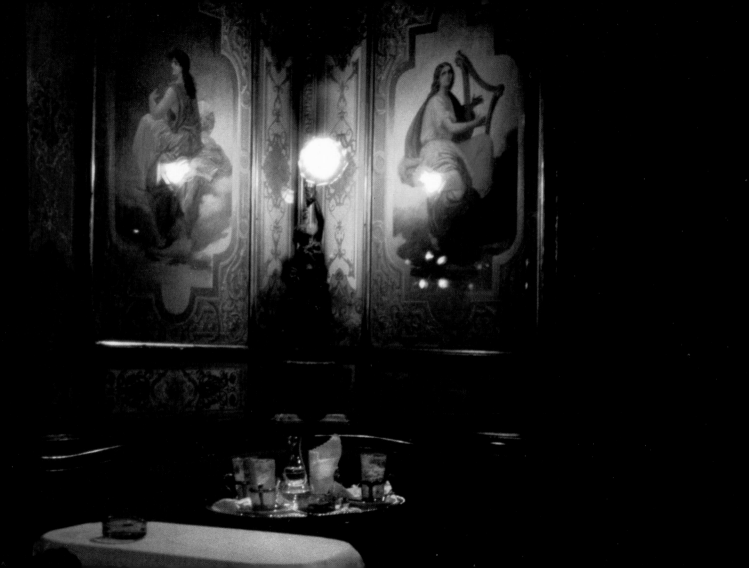

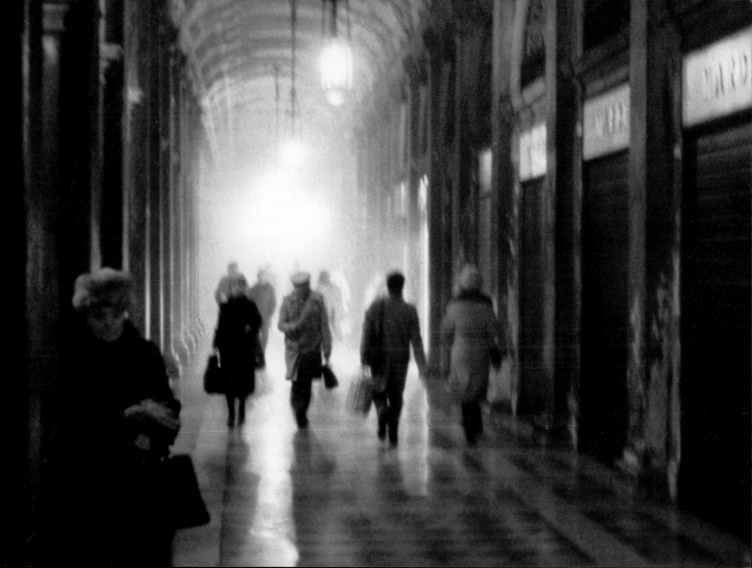

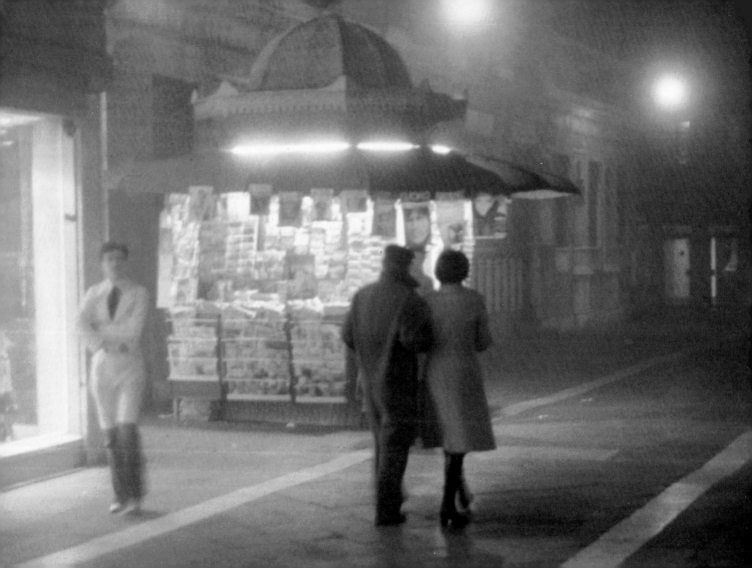

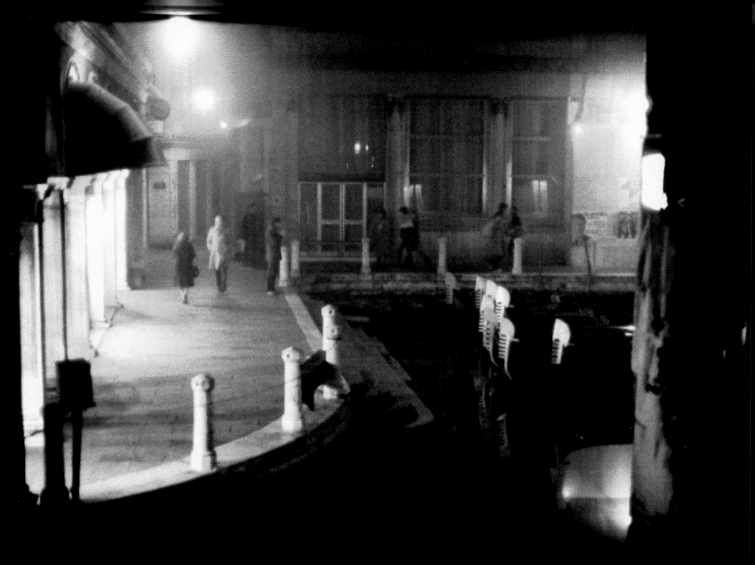

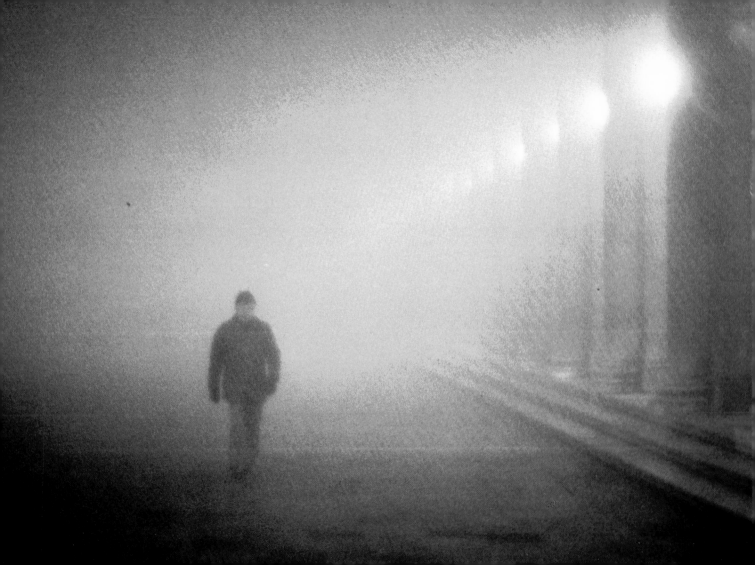

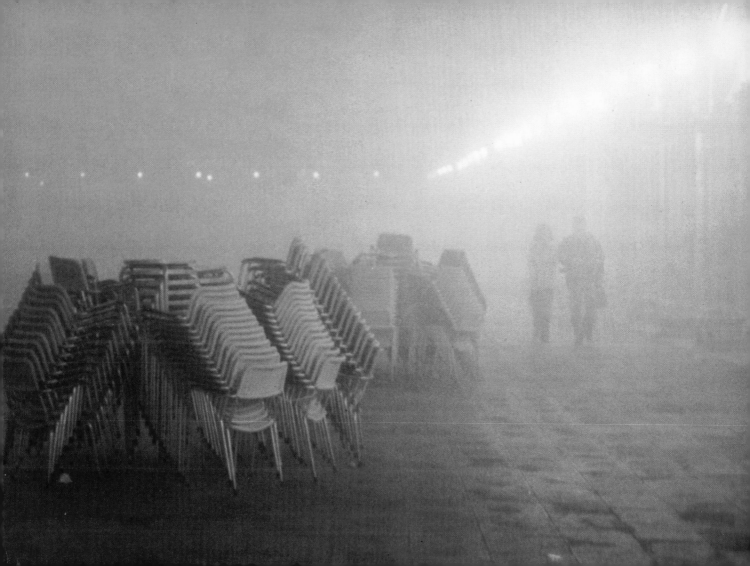

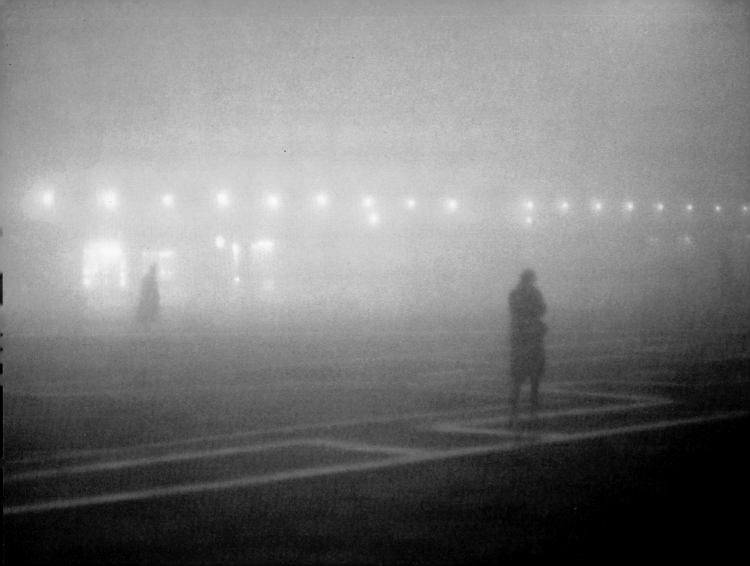

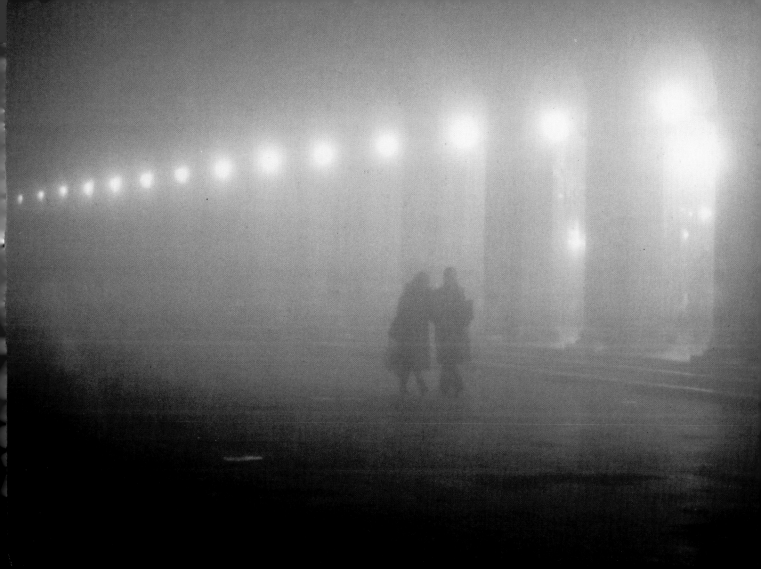

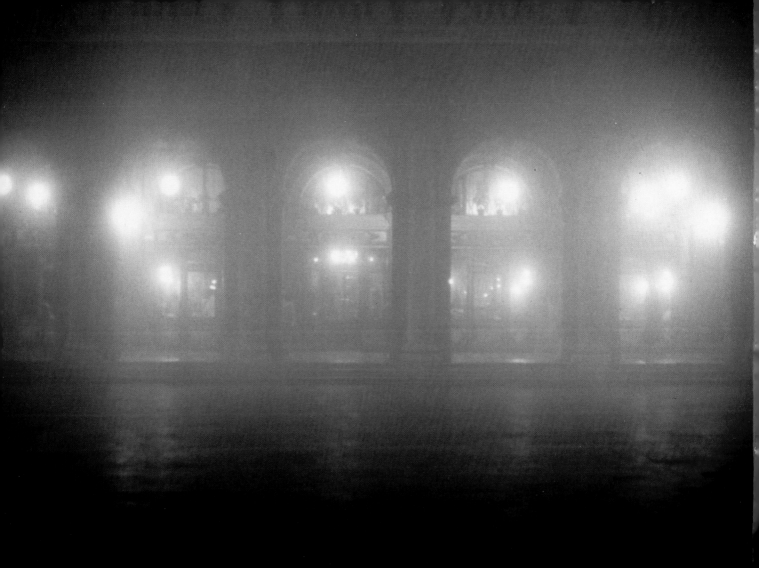

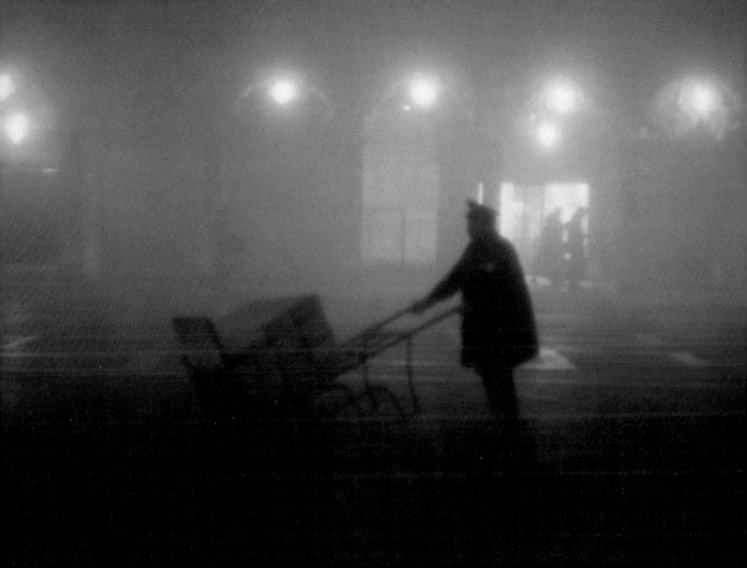

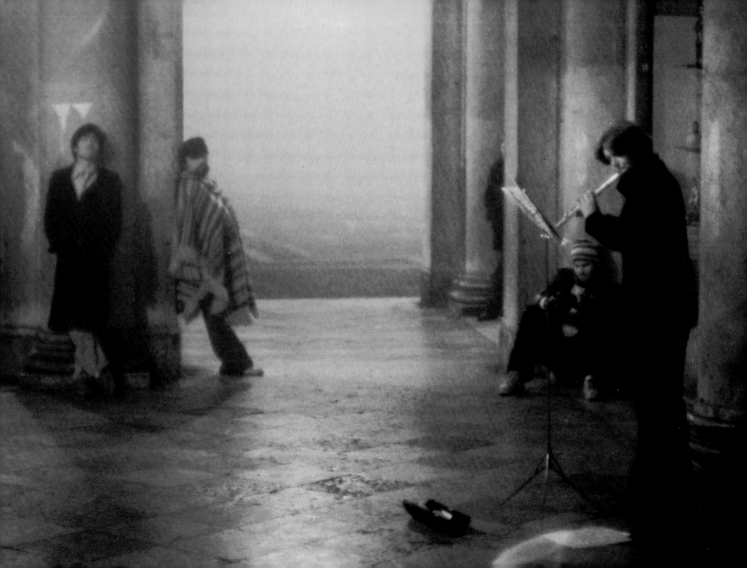

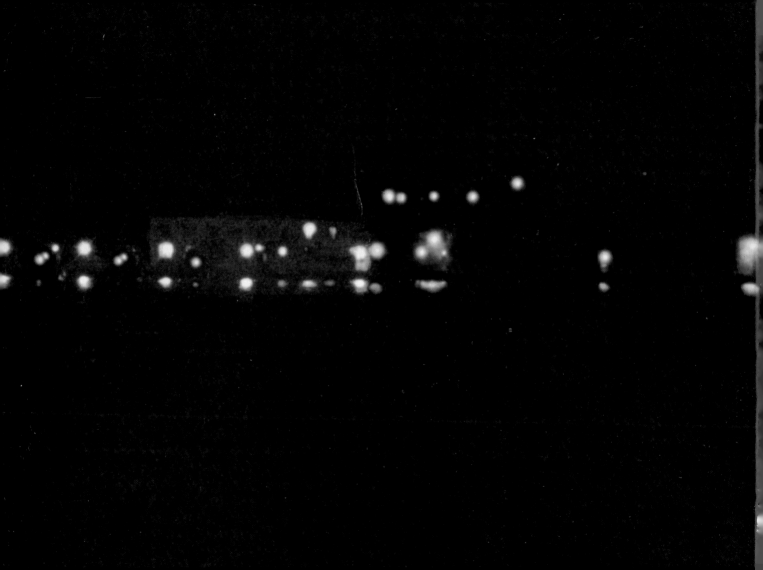

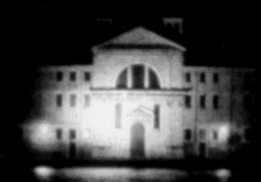

Ted Scapa lives and works in Bern, Switzerland.
The photos were taken during various late fall
visits to Venice.

First U.S. edition 1980
Barron's Educational Series, Inc.
113 Crossways Park Drive
Woodbury, New York 11797

© 1979 text and photos, Scapa/Benteli Verlag Bern, Switzerland

International Standard Book No. 0-8120-5392-3

Printer: Benteli AG, 3018 Bern
PRINTED IN SWITZERLAND